DECORATIVE ALPHABETS

A Coloring Book of Letters & Borders

MOLLY SUBER THORPE

Author of Mastering Modern Calligraphy

This book belongs to

MORE BOOKS BY MOLLY SUBER THORPE:

Mastering Modern Calligraphy
Beyond the Basics: 2,700+ Pointed Pen Exemplars
and Exercises for Developing Your Style

Modern Calligraphy
Everything You Need to Know
to Get Started in Script Calligraphy

The Calligrapher's Business Handbook
Pricing and Policies for Lettering Artists

Decorative Alphabets
is a coloring book for lettering
enthusiasts of all ages.

◆

Color for fun. Color to learn.

The intricate letter and border
designs in *Decorative Alphabets*
provide a relaxing art experience, but
the appeal does not end there. This is
also a book for hand lettering artists
looking for letterform inspiration and
traceable designs.

These 50+ decorated alphabets and
majuscules are a modern take on type
specimen books of old. Use this book to
learn new lettering styles by tracing the
exemplars, or just have fun by coloring
the ornate illustrations.

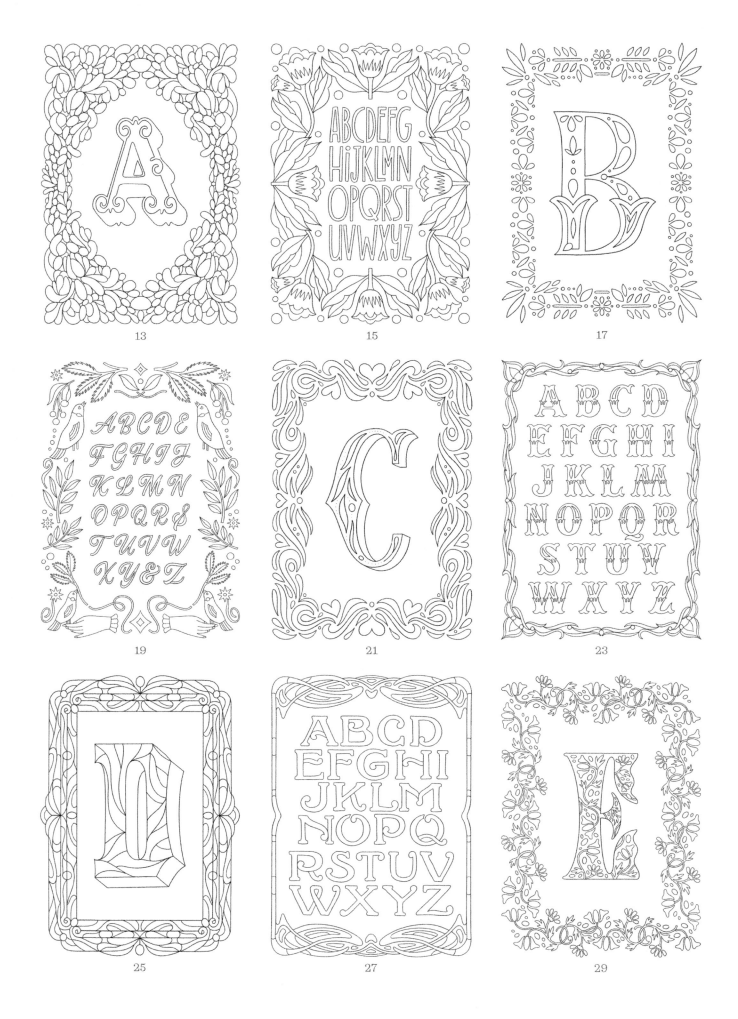

13

15

17

19

21

23

25

27

29

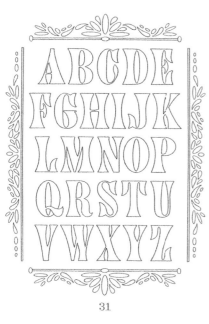

31

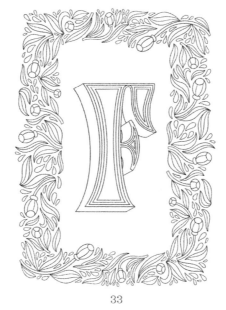

33

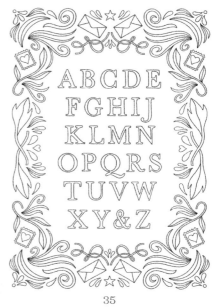

35

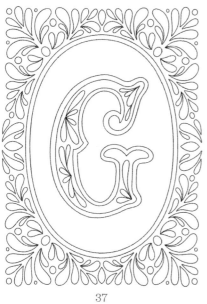

37

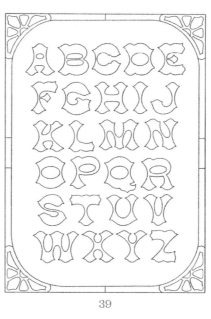

39

41

43

45

47

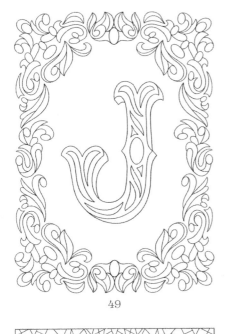

49

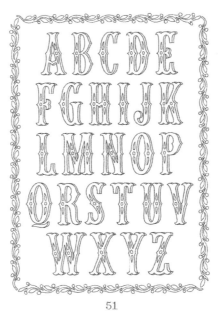

51

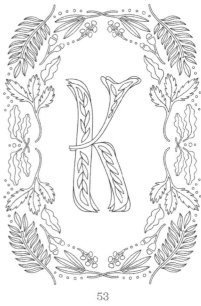

53

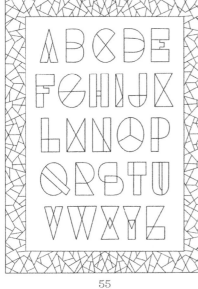

55

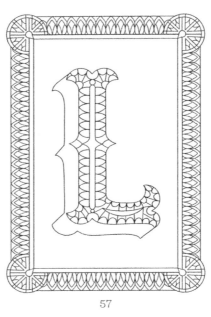

57

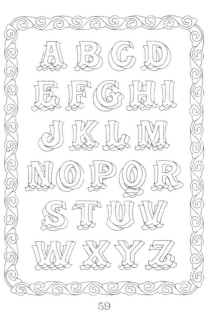

59

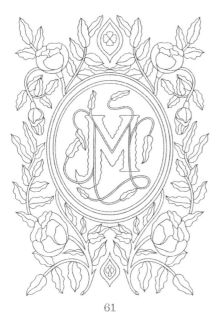

61

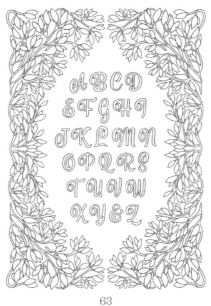

63

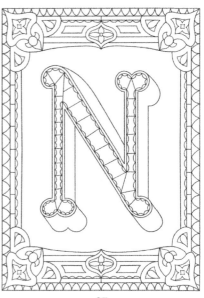

65

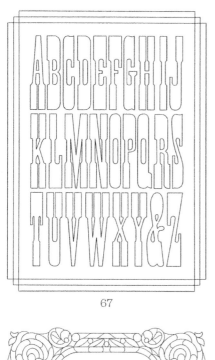

67

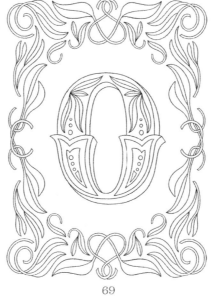

69

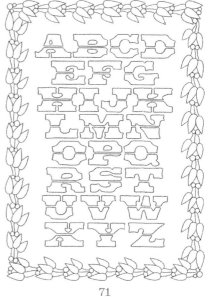

71

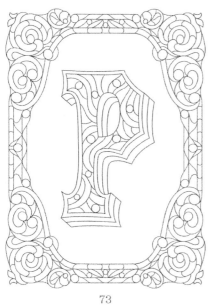

73

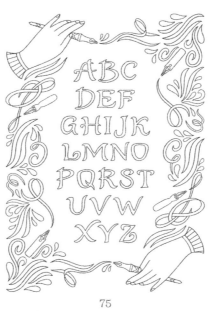

75

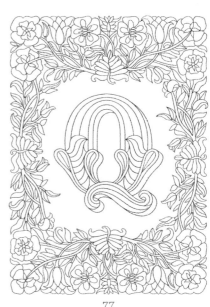

77

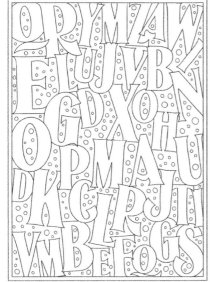

79

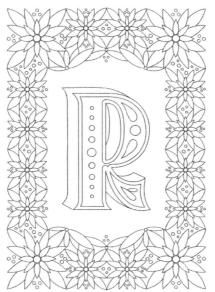

81

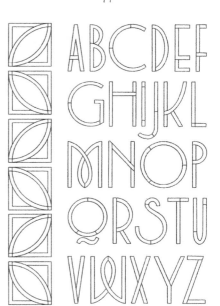

83

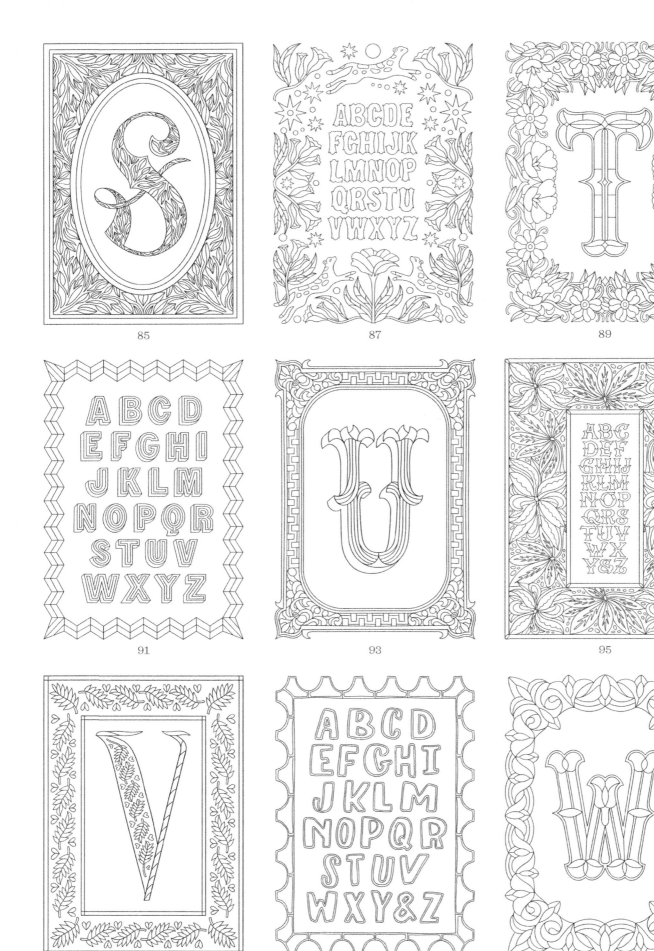

85

87

89

91

93

95

97

99

101

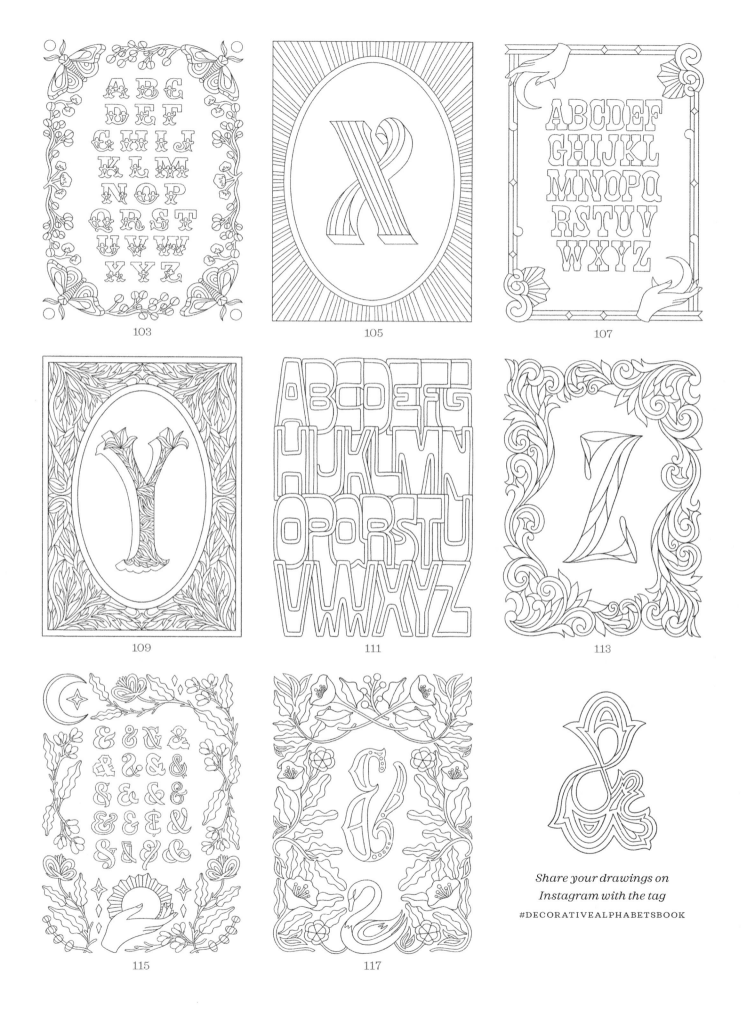

103

105

107

109

111

113

115

117

*Share your drawings on
Instagram with the tag*
#DECORATIVEALPHABETSBOOK

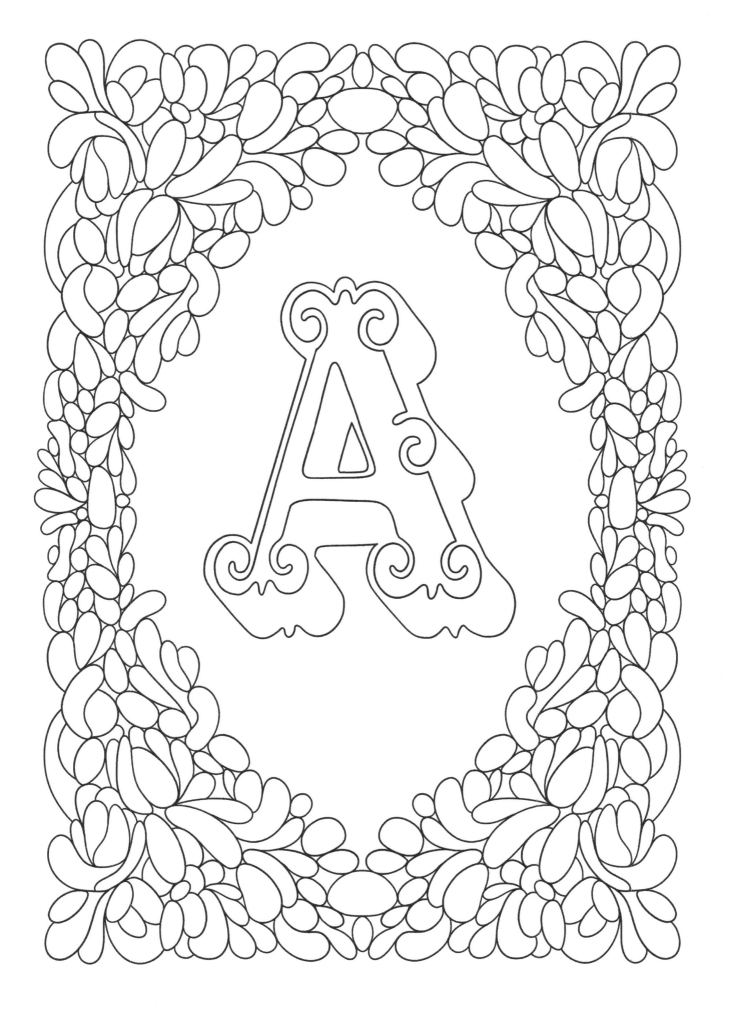

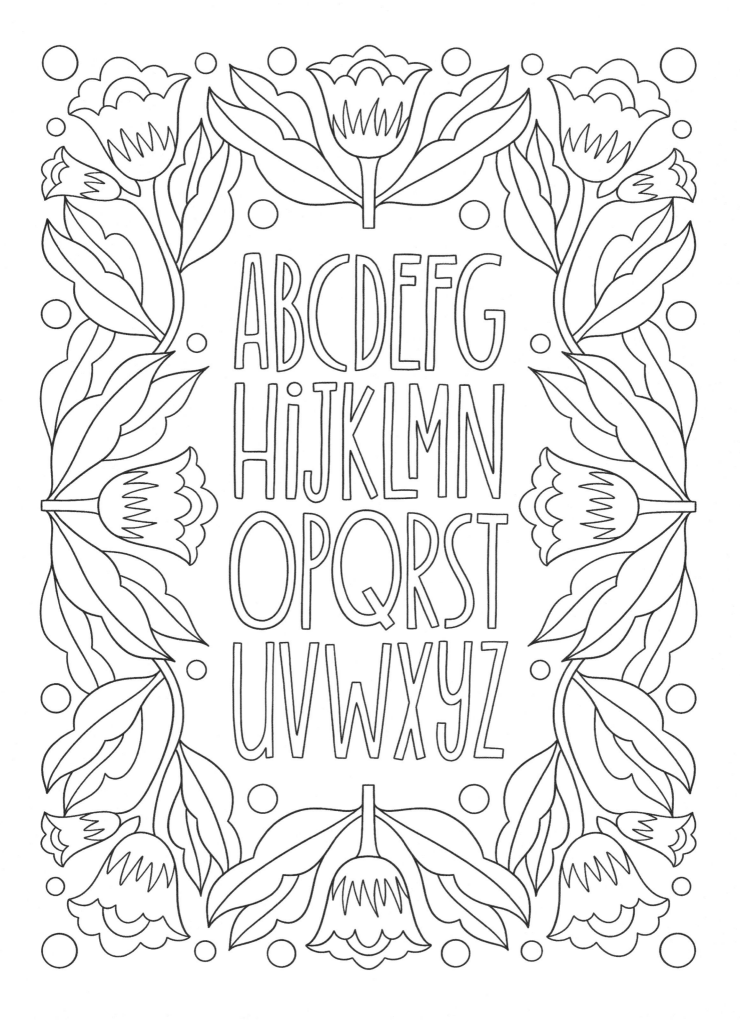

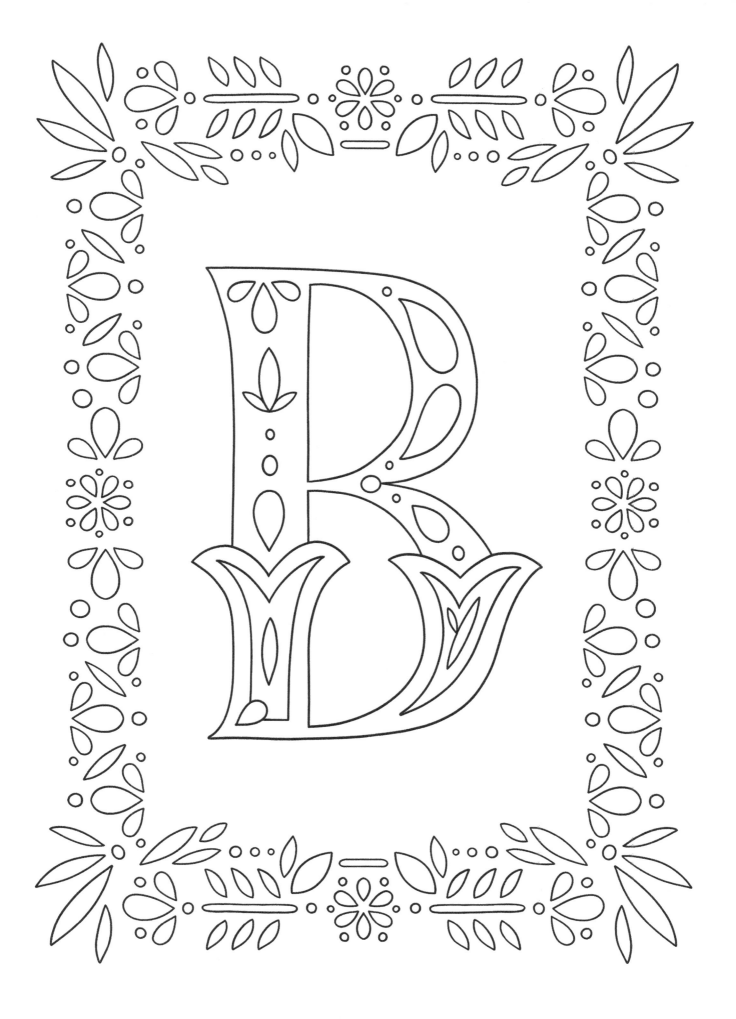

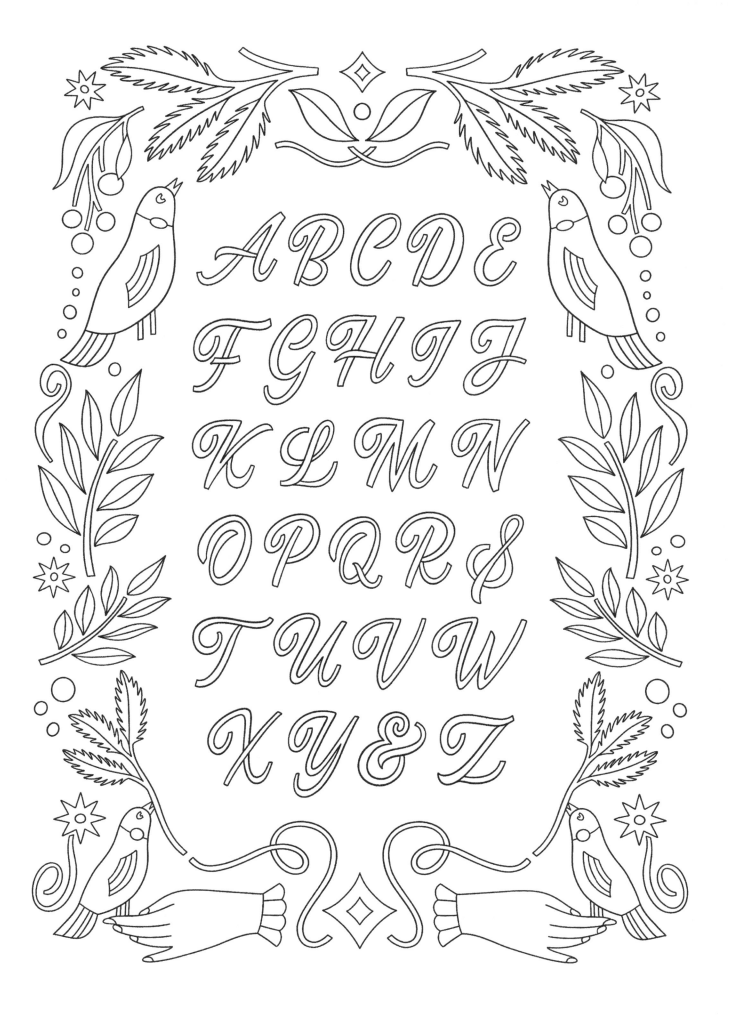

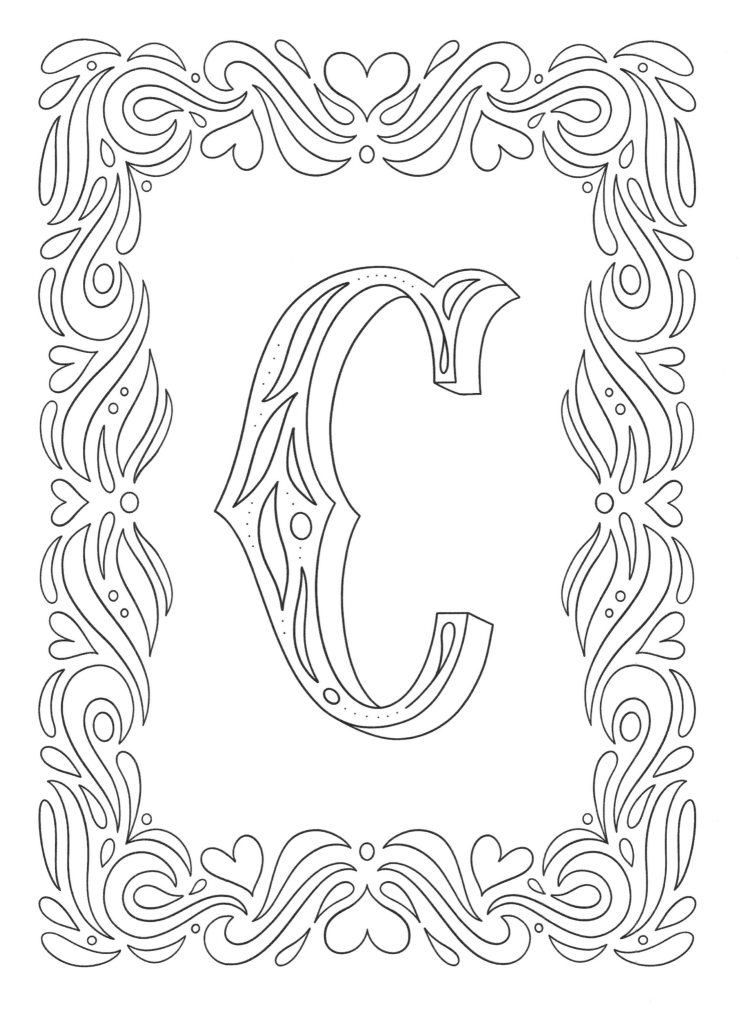

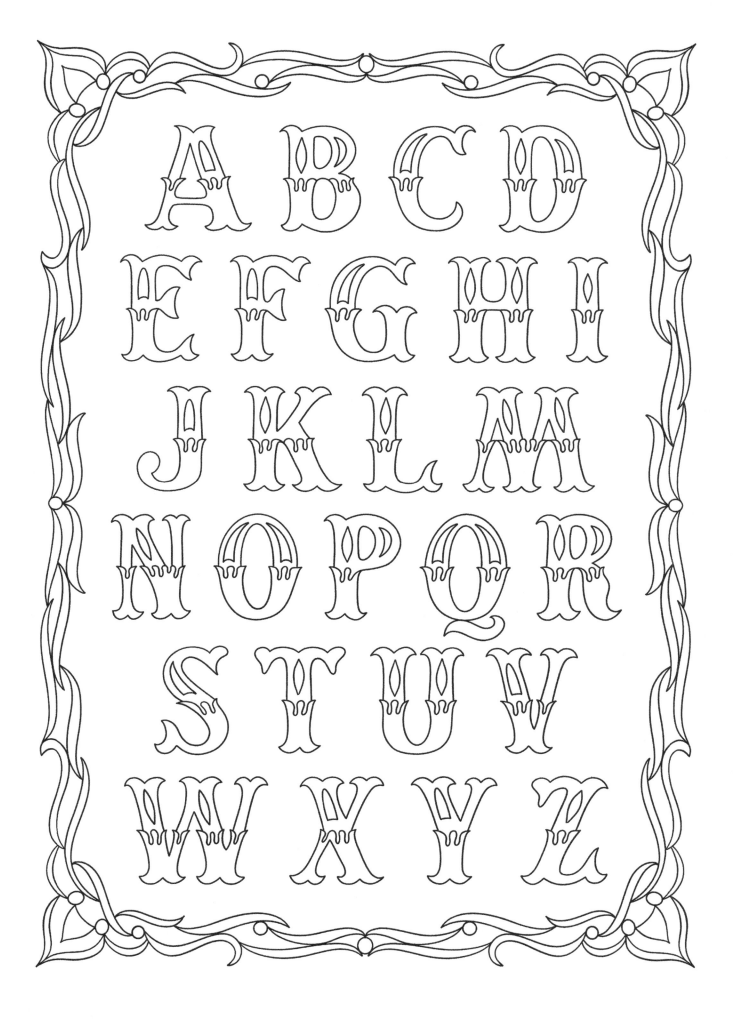

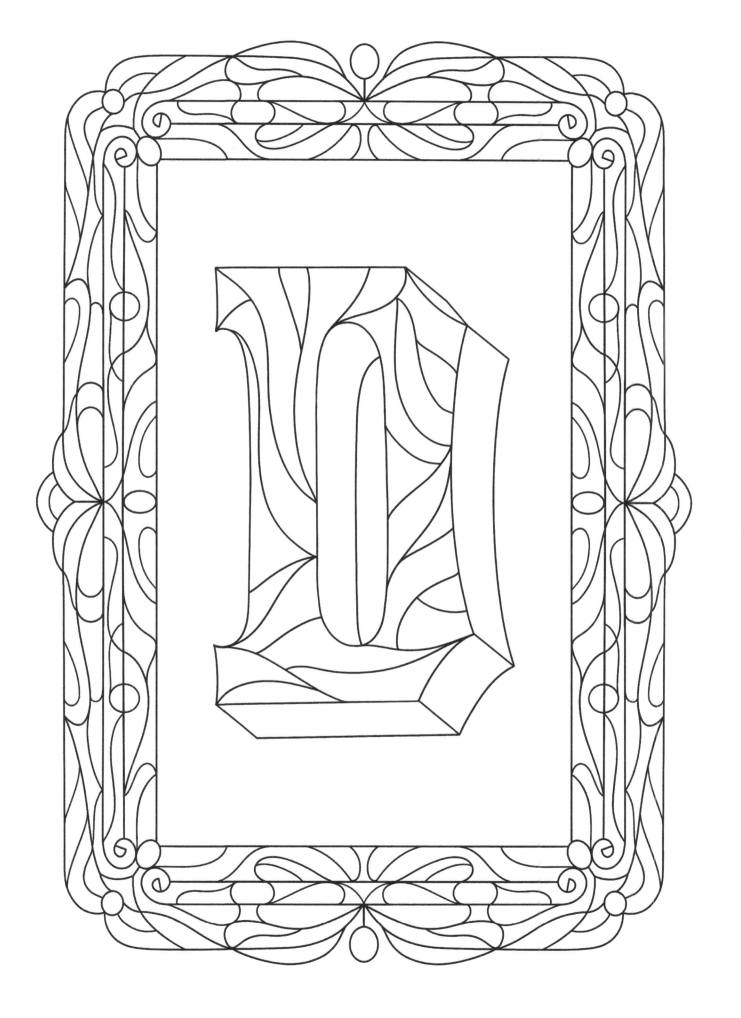

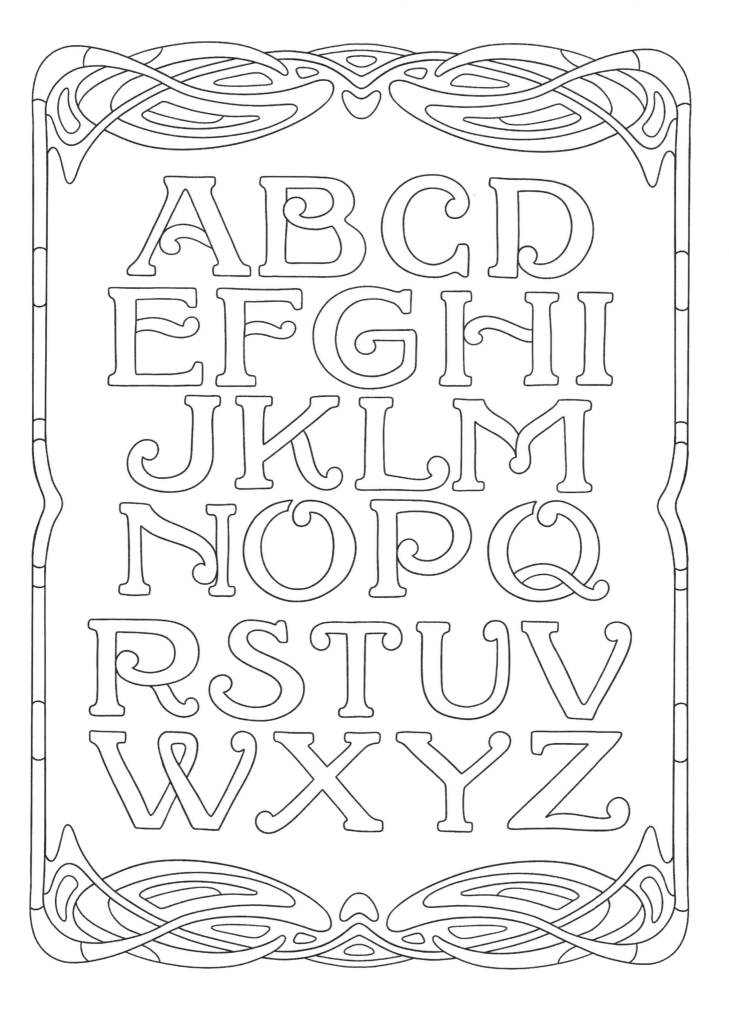

ABCDE
FGHIJK
LMNOP
QRSTU
VWXYZ

ABCDE
FGHIJK
LMNOP
QRSTU
VWXYZ

ABCDE
FGHIJK
LMNOP
QRSTUV
WXYZ

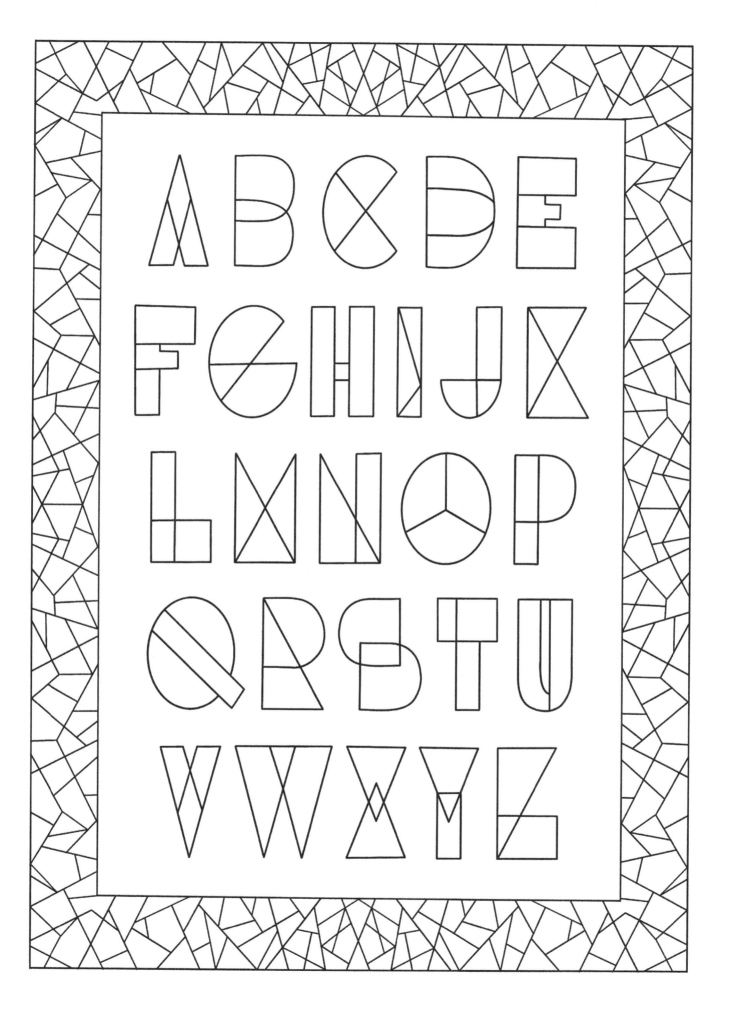

A B C D
E F G H I
J K L M
N O P Q R
S T U V
W X Y Z

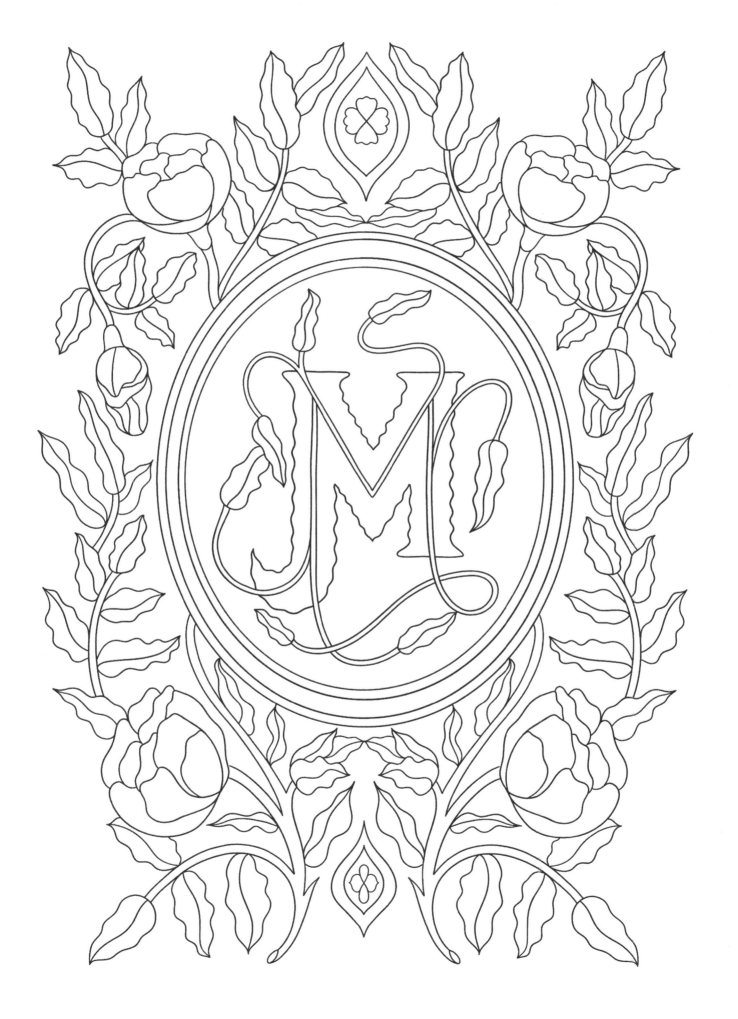

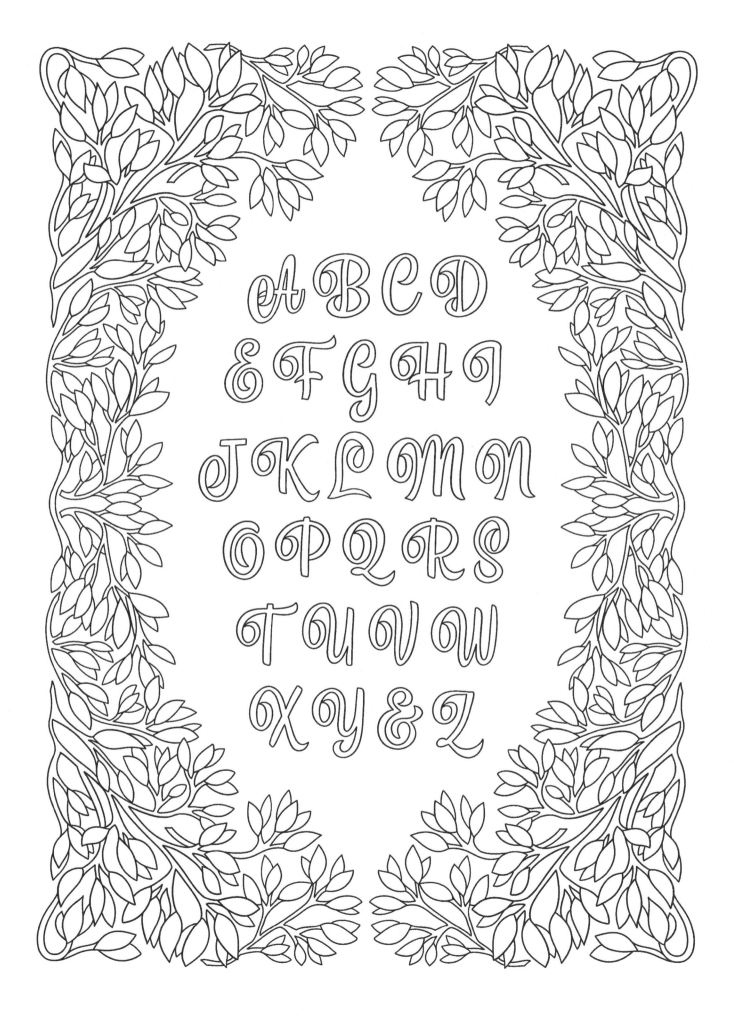

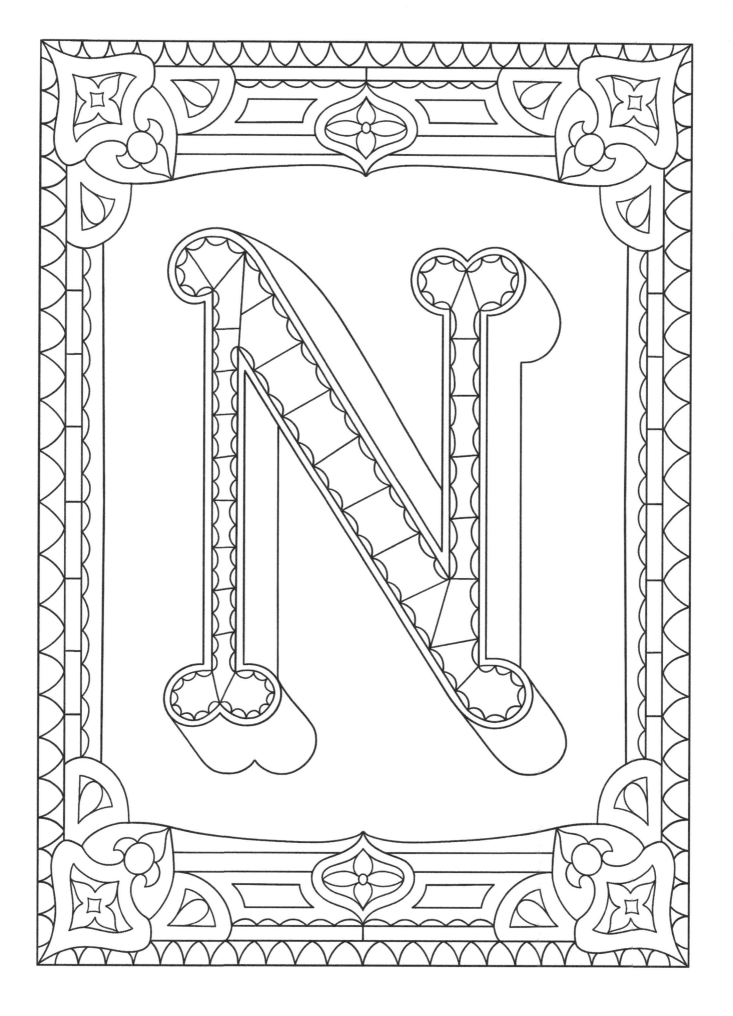

ABCDEFGHIJ

KLMNOPQRS

TUVWXY&Z

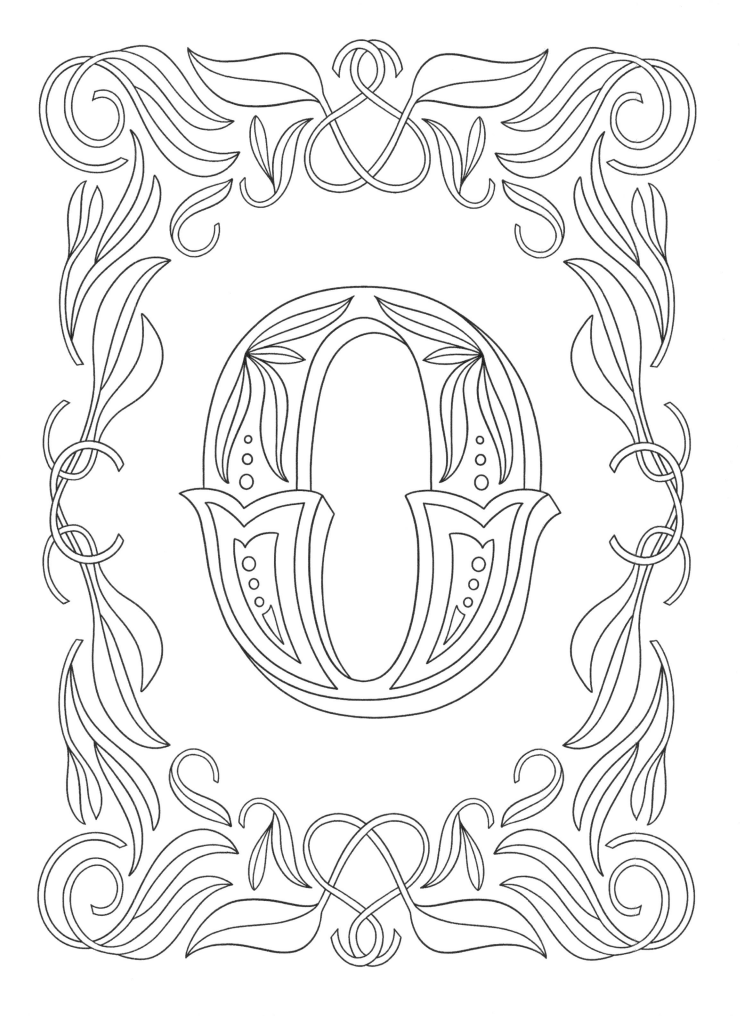

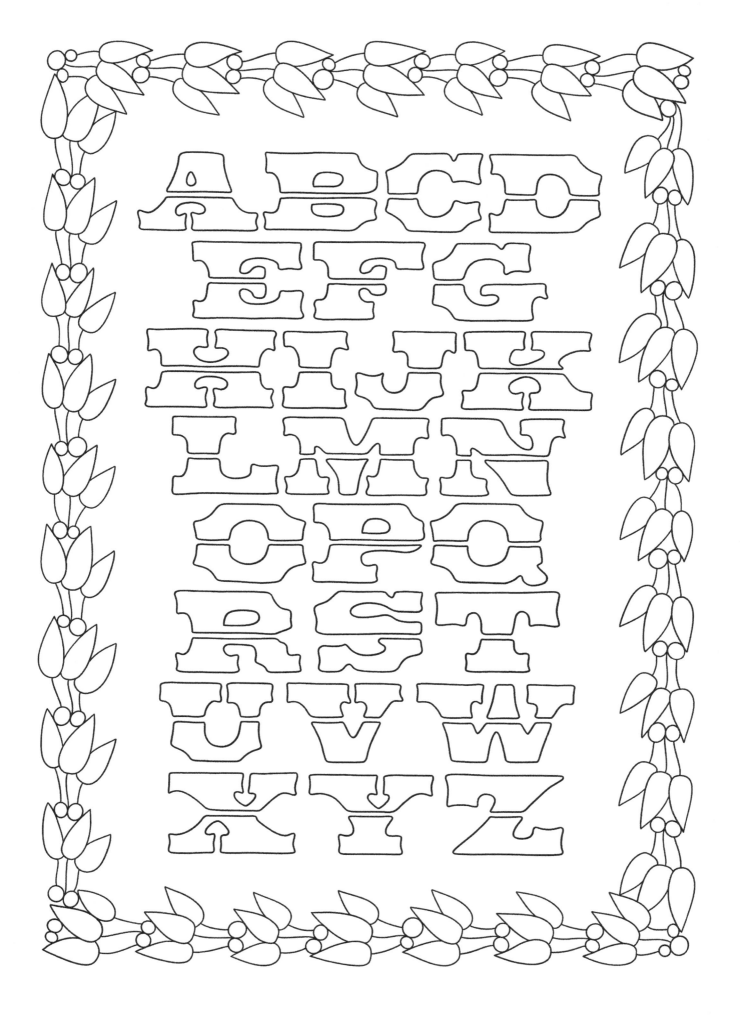

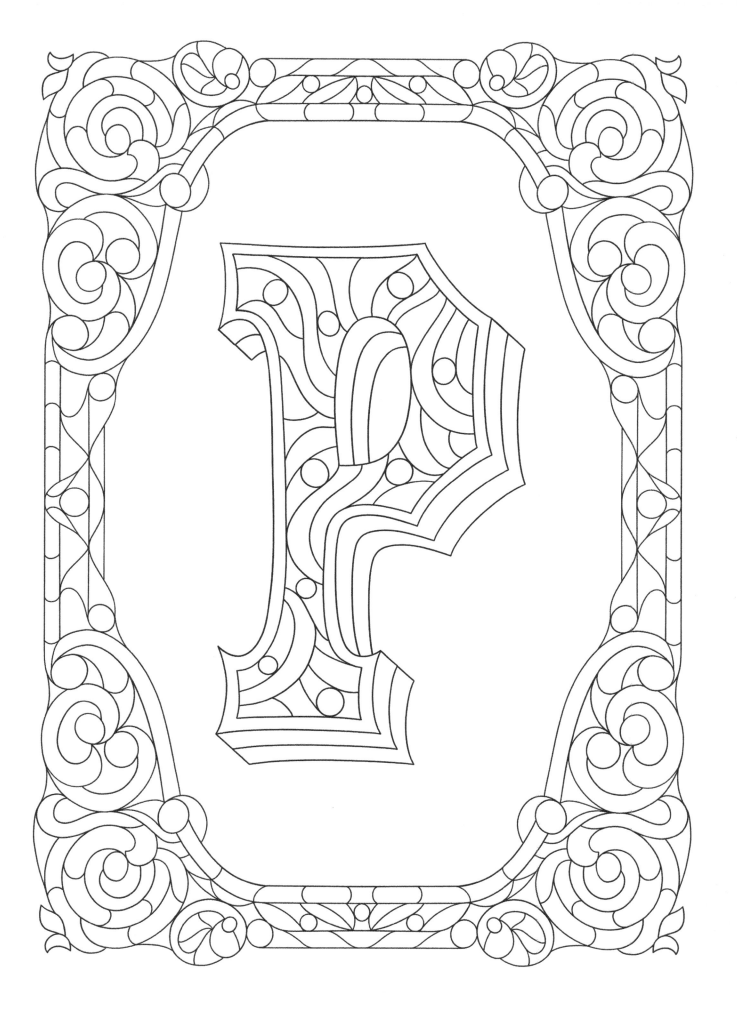

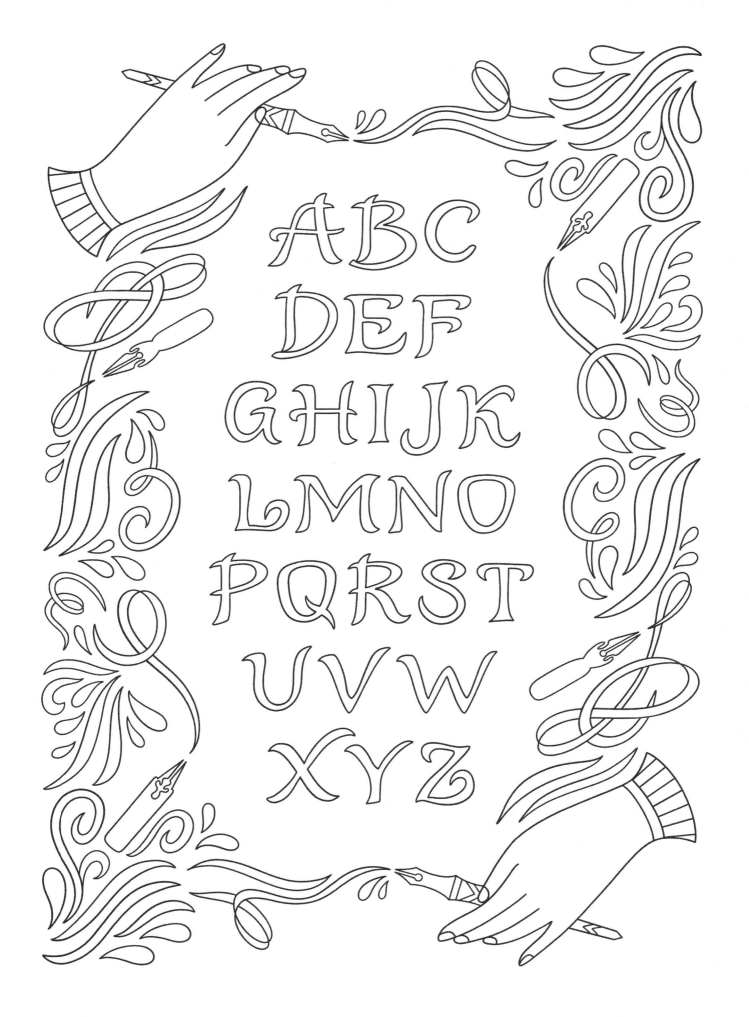

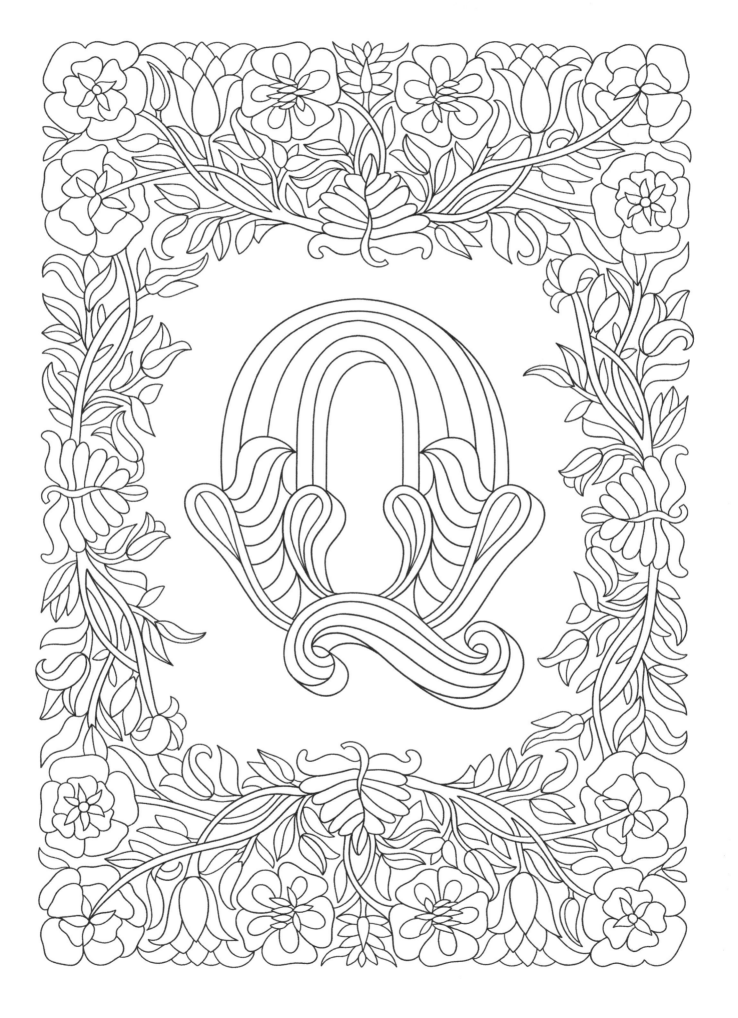

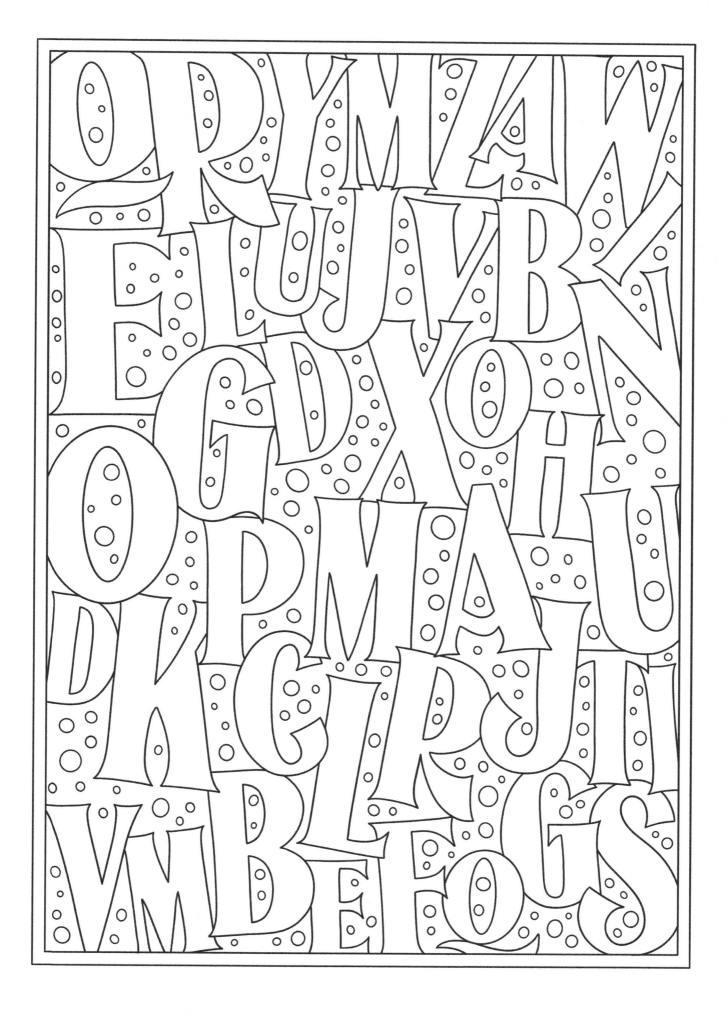

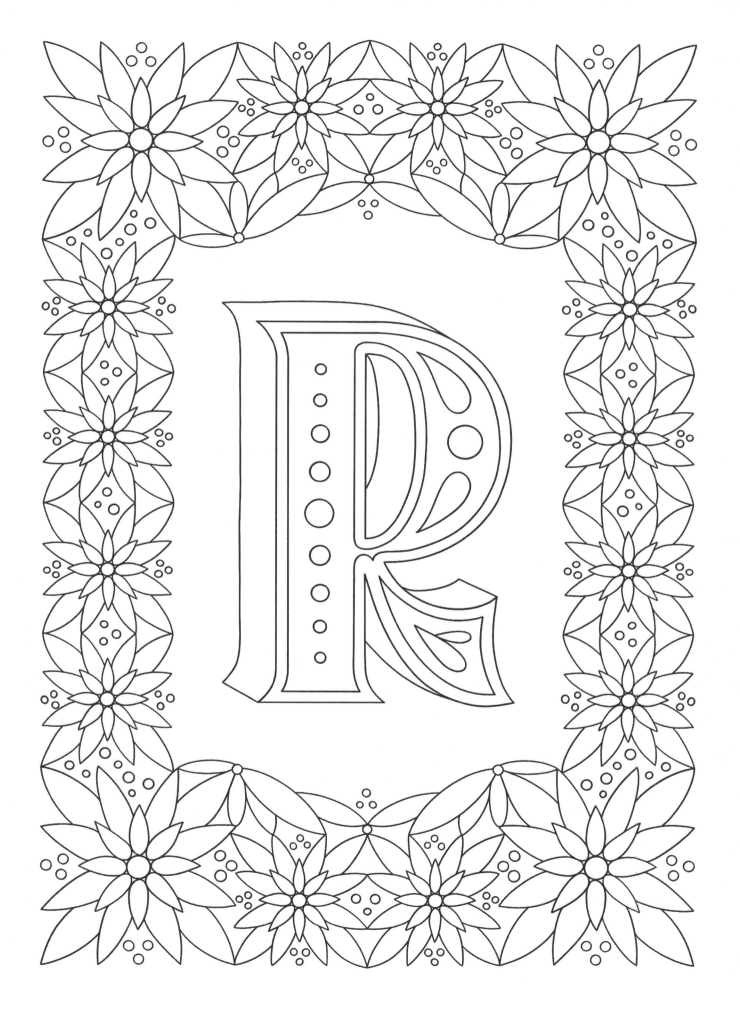

ABCDEF
GHIJKL
MNOP
QRSTU
VWXYZ

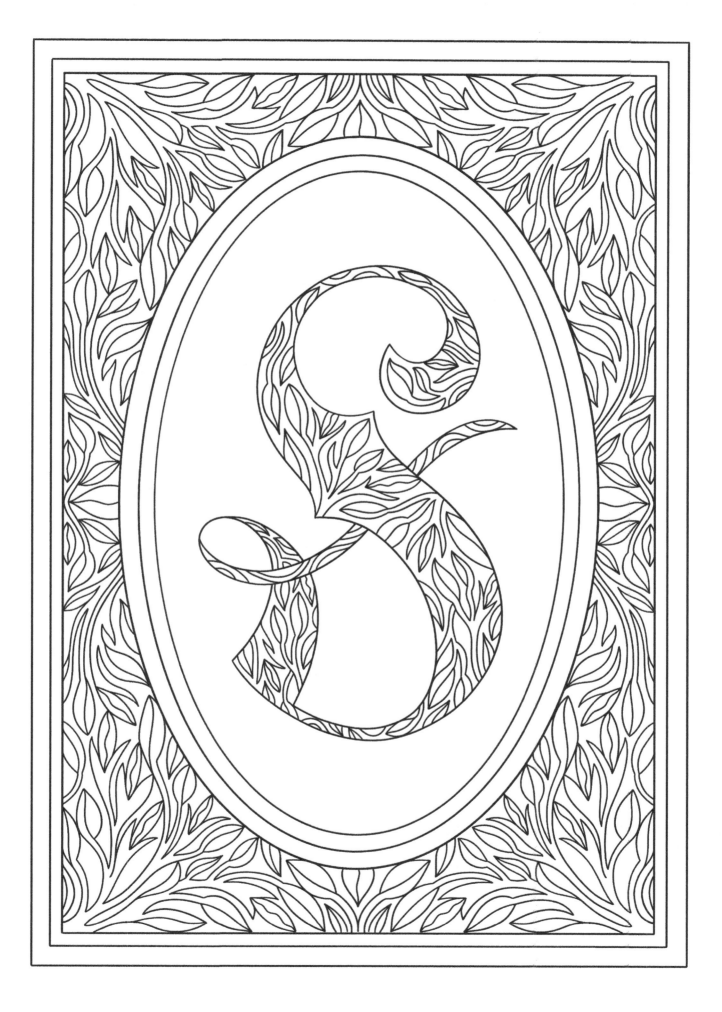

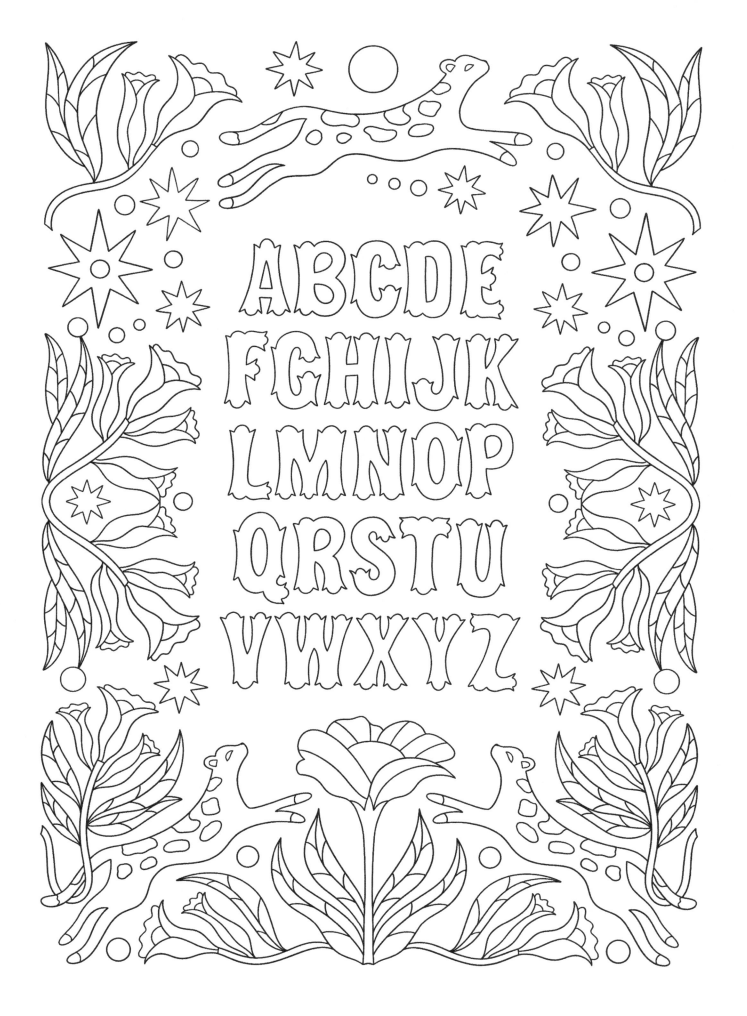

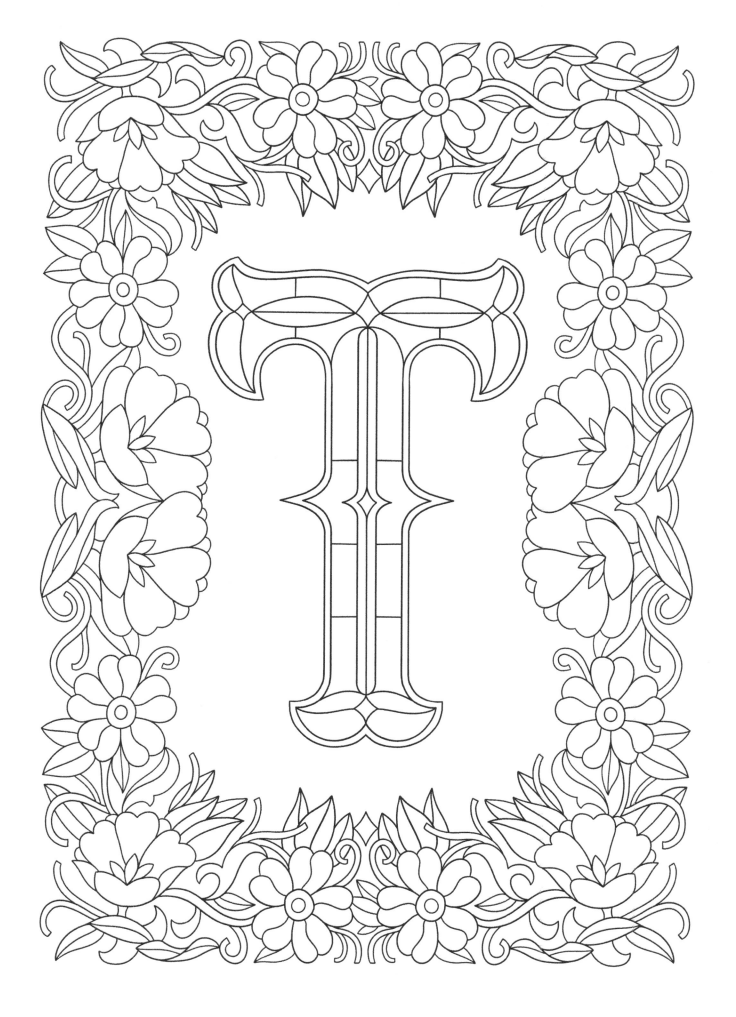

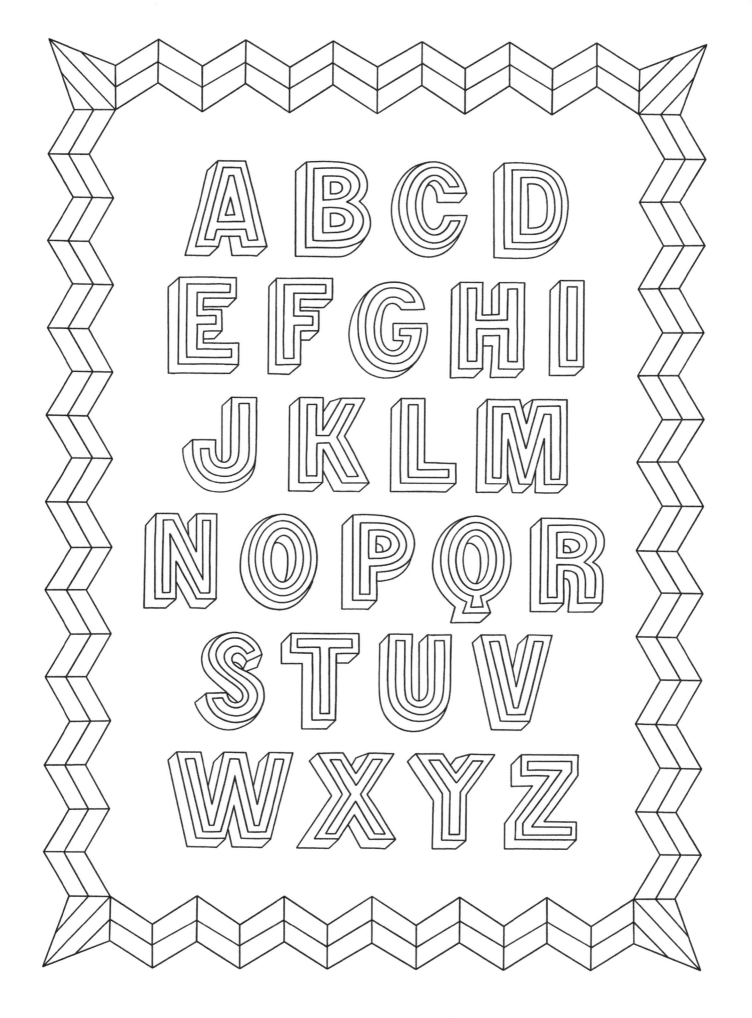

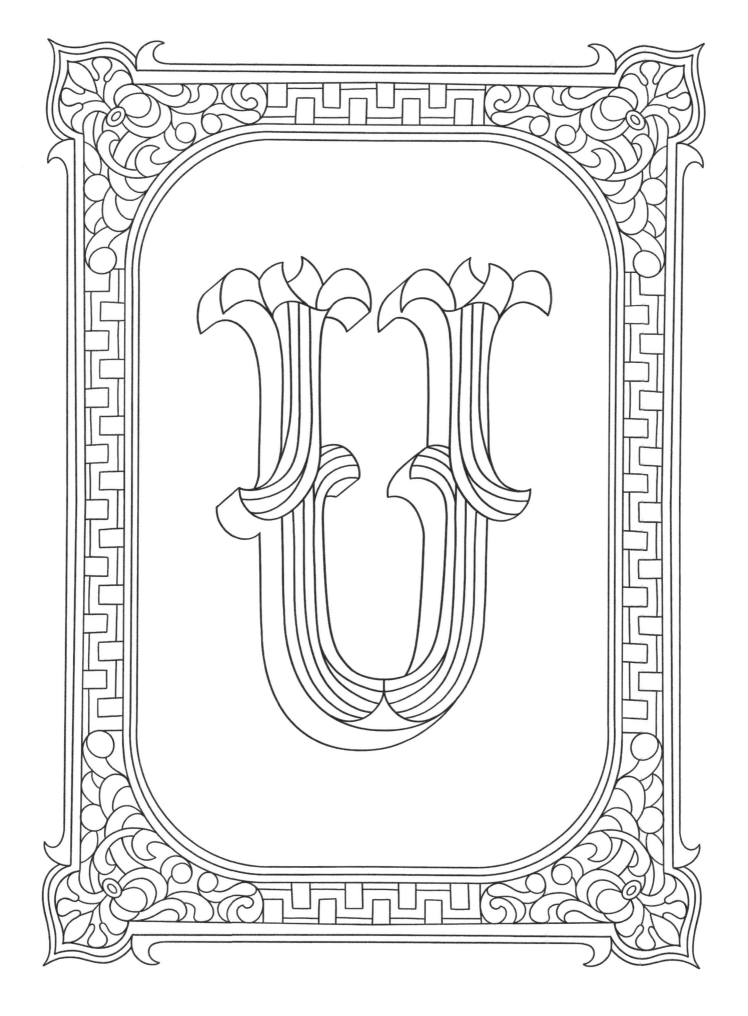

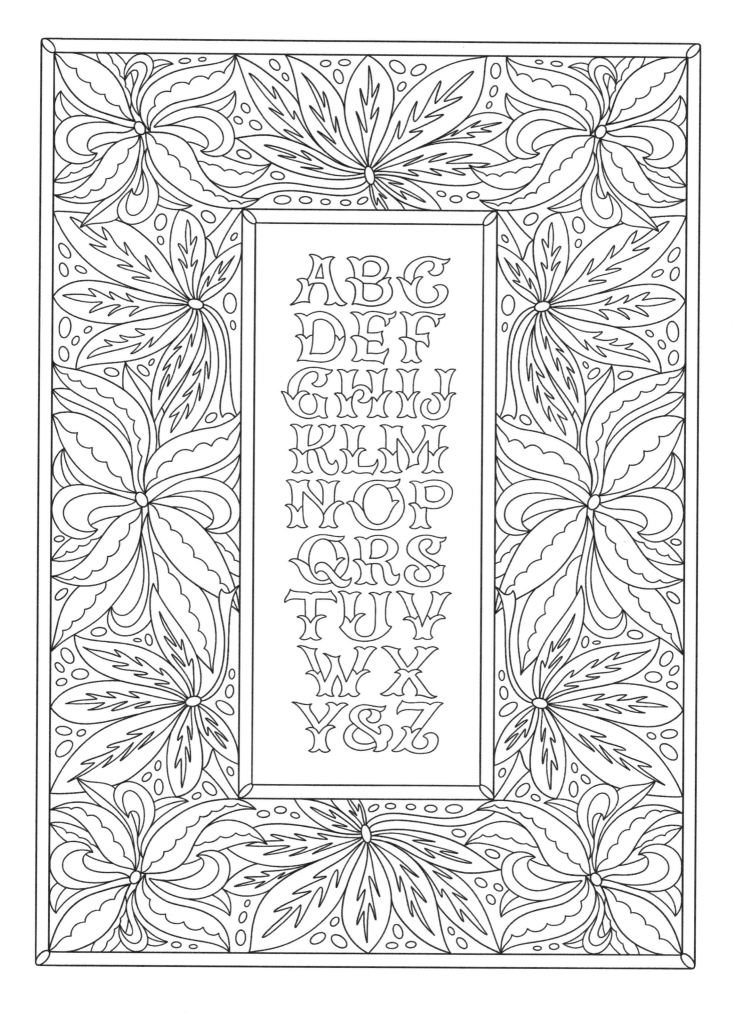

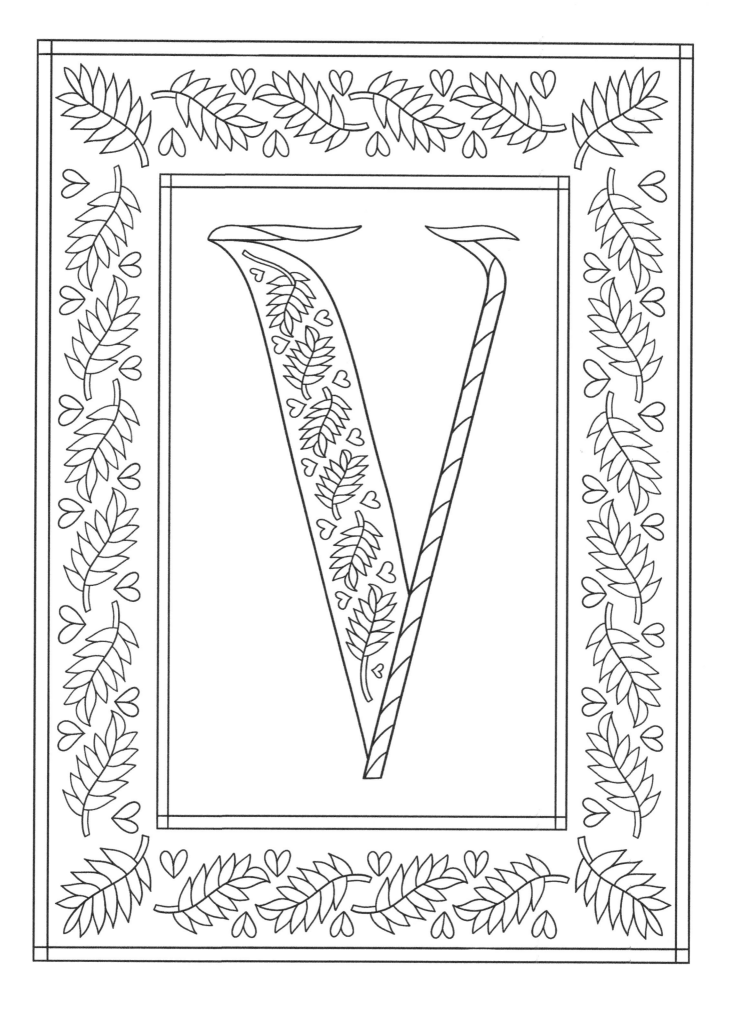

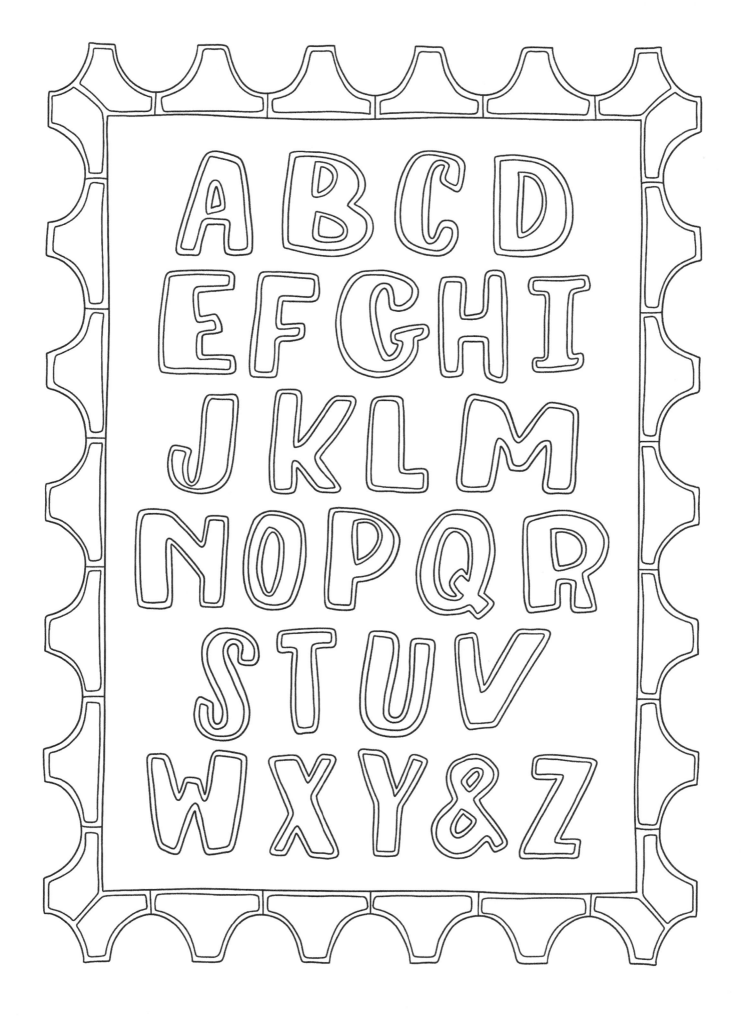

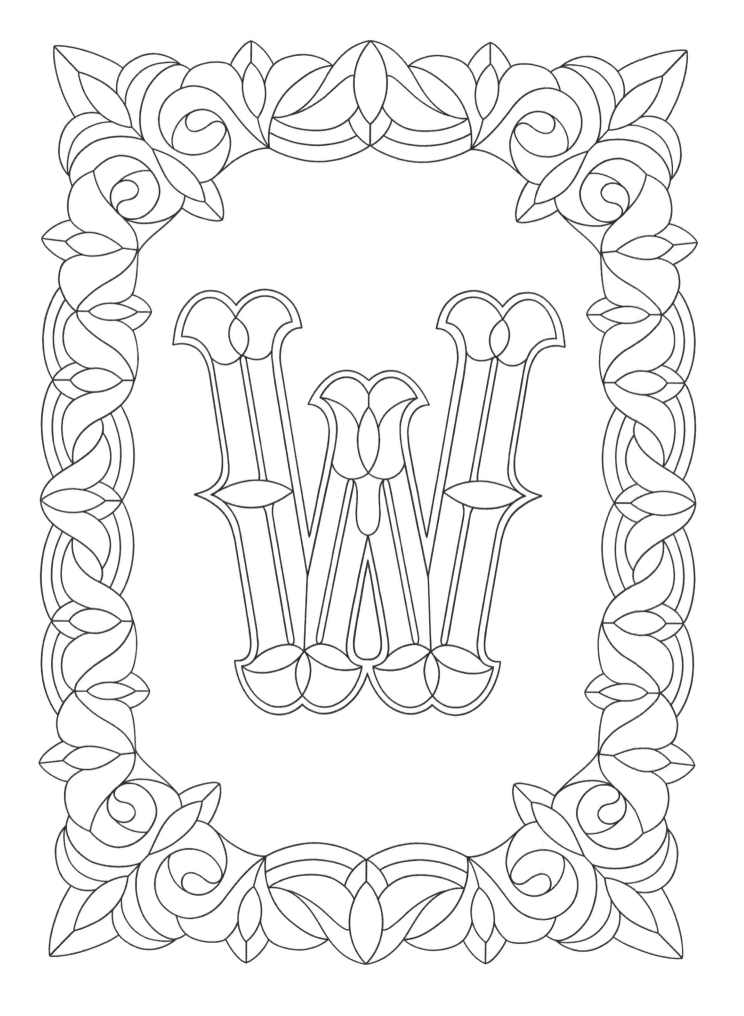

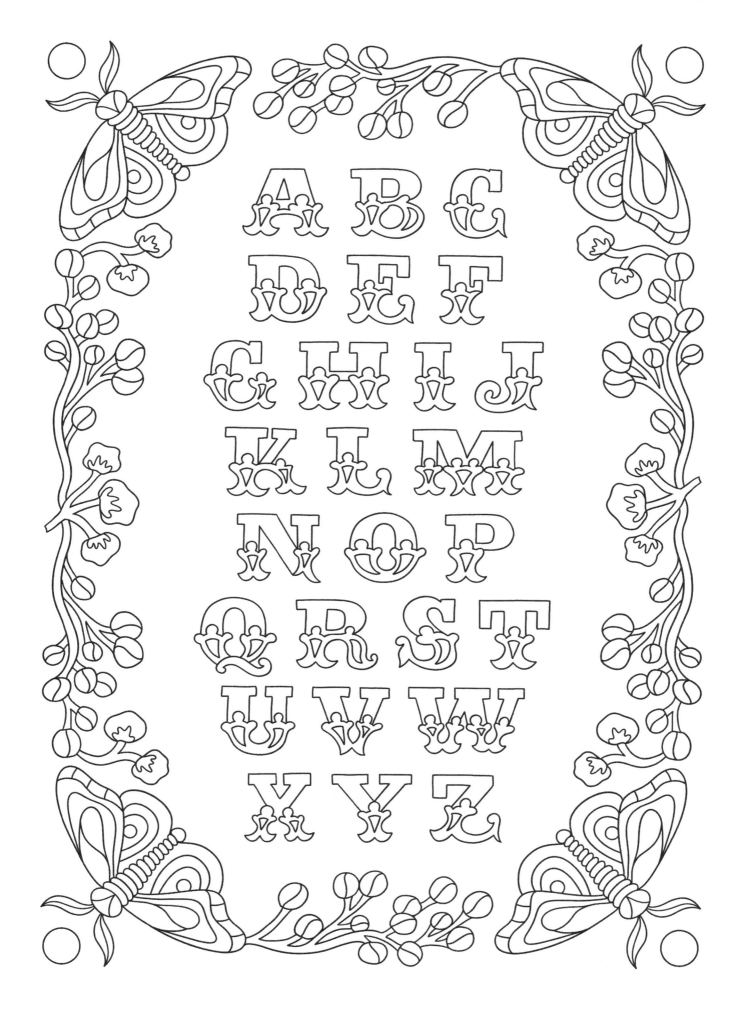

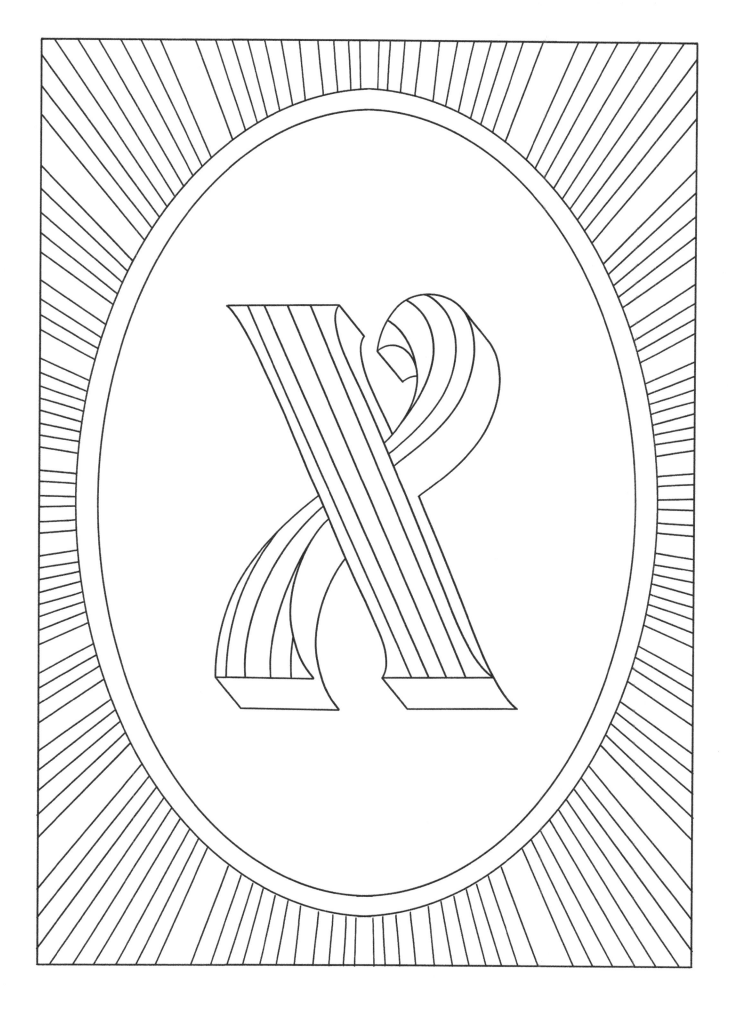

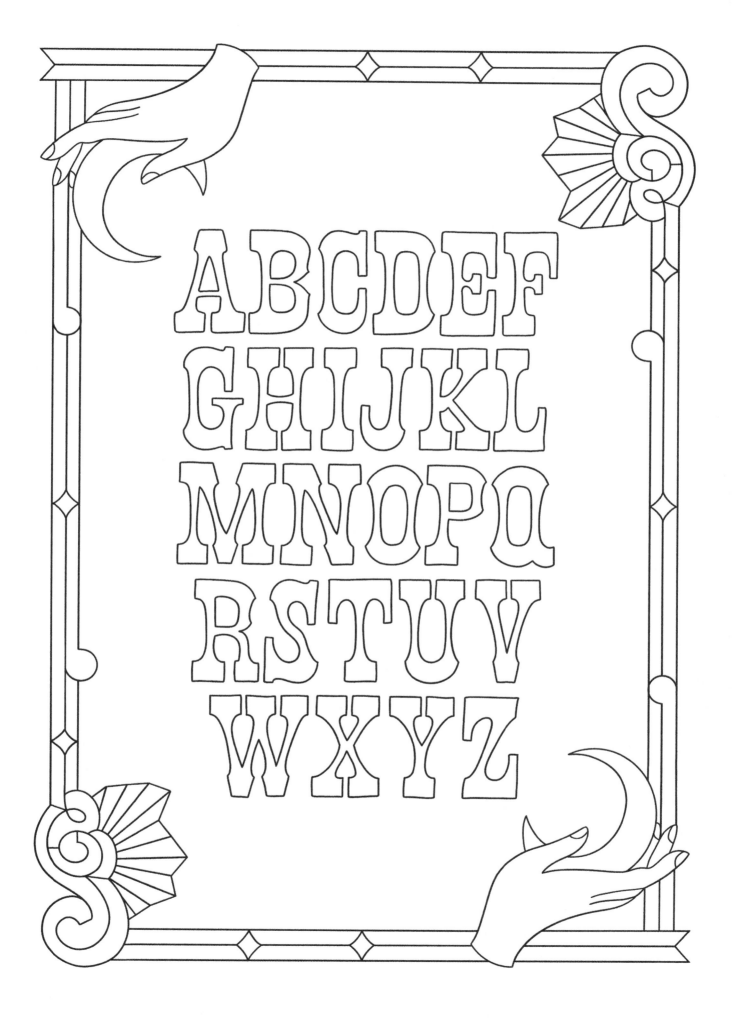

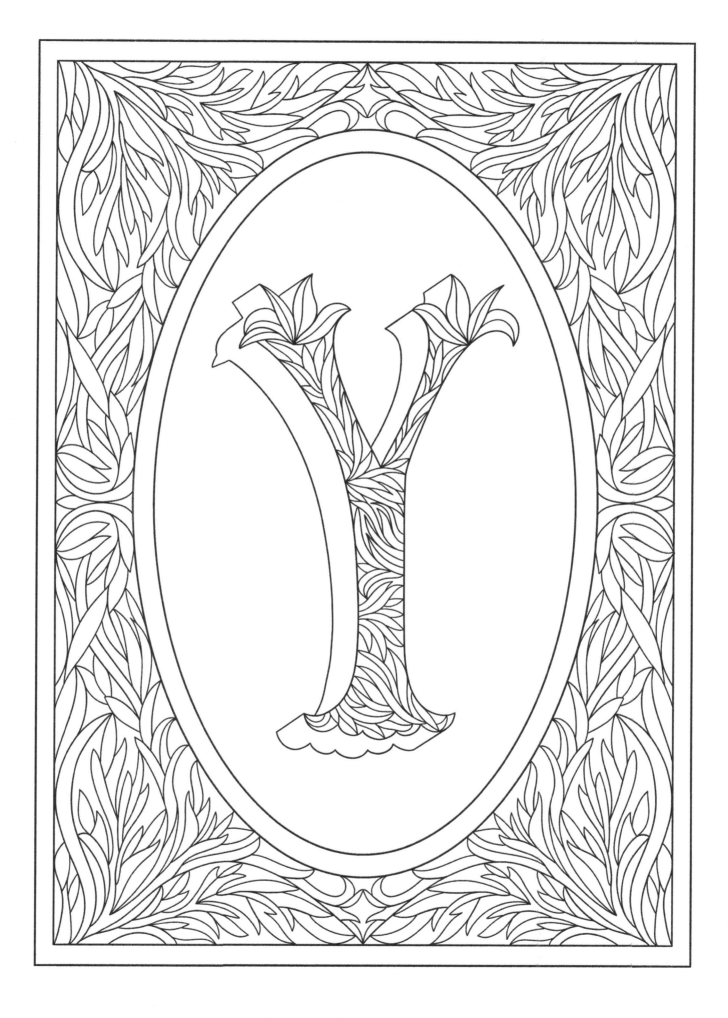

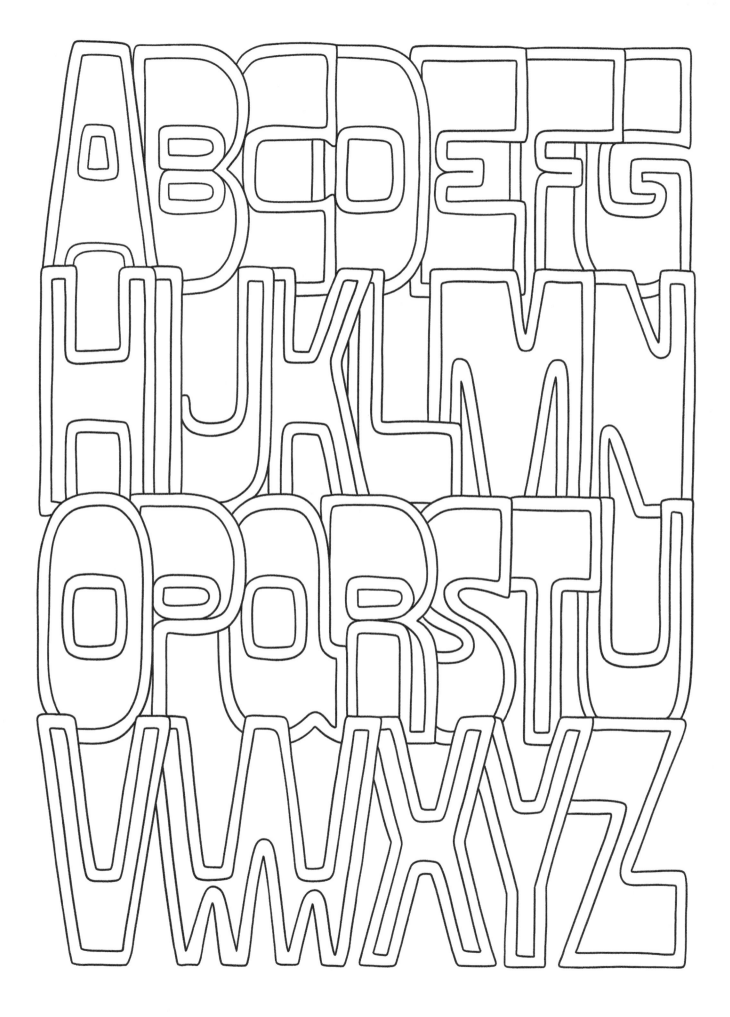

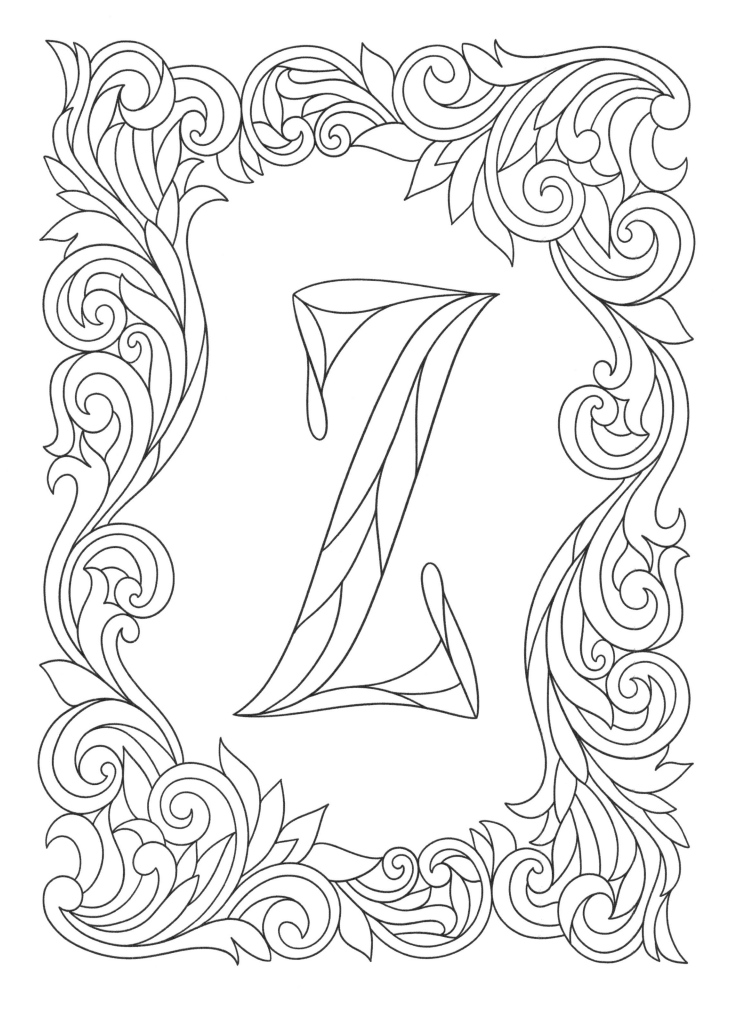

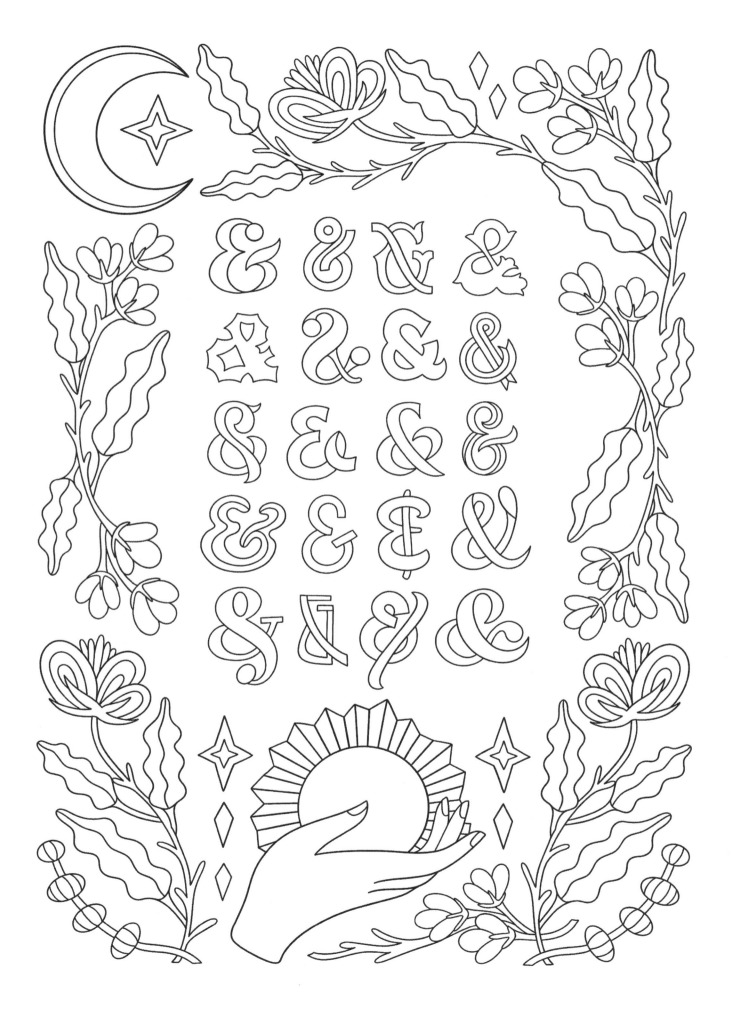

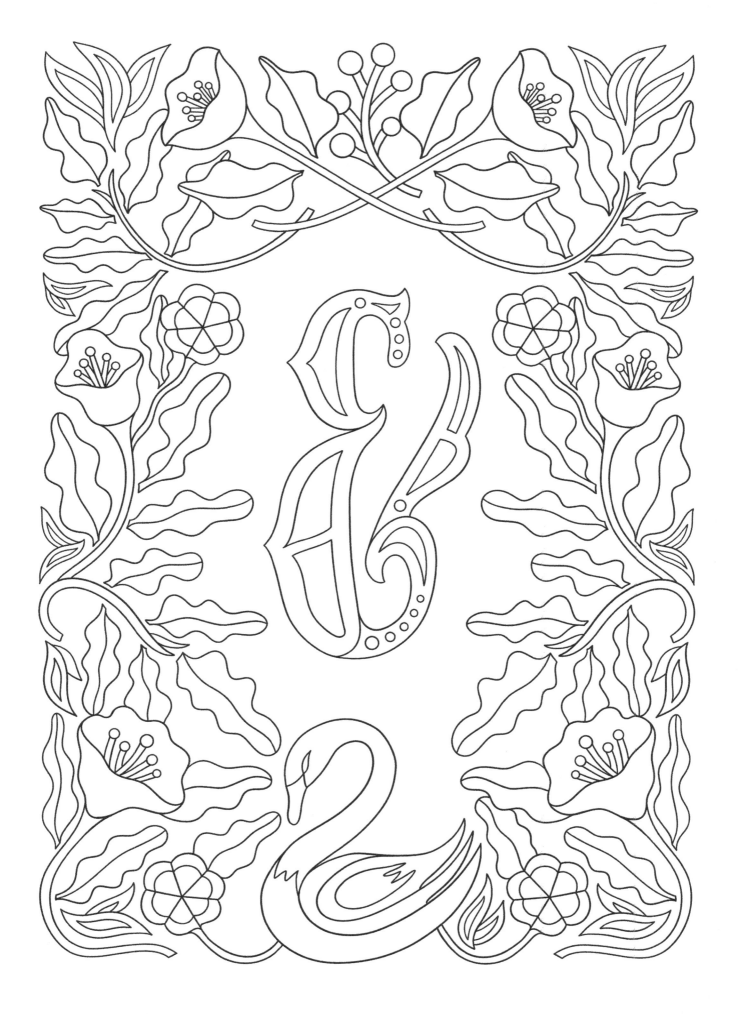

MOLLYSUBERTHORPE.COM

About the author

Molly Suber Thorpe designs custom
lettering for brands and individuals
around the world, digital products
for artists, and educational content
for calligraphers.

Since 2012, Molly has helped
letterers hone their skills – through
her books, classes, and tools –
opening doors to new creative
opportunities and careers.

Share your drawings on
Instagram with the tag:
#DECORATIVEALPHABETSBOOK

Tag me so I can have a peek:
@MOLLYSUBERTHORPE

Made in the USA
Monee, IL
25 July 2023

39877957R00070